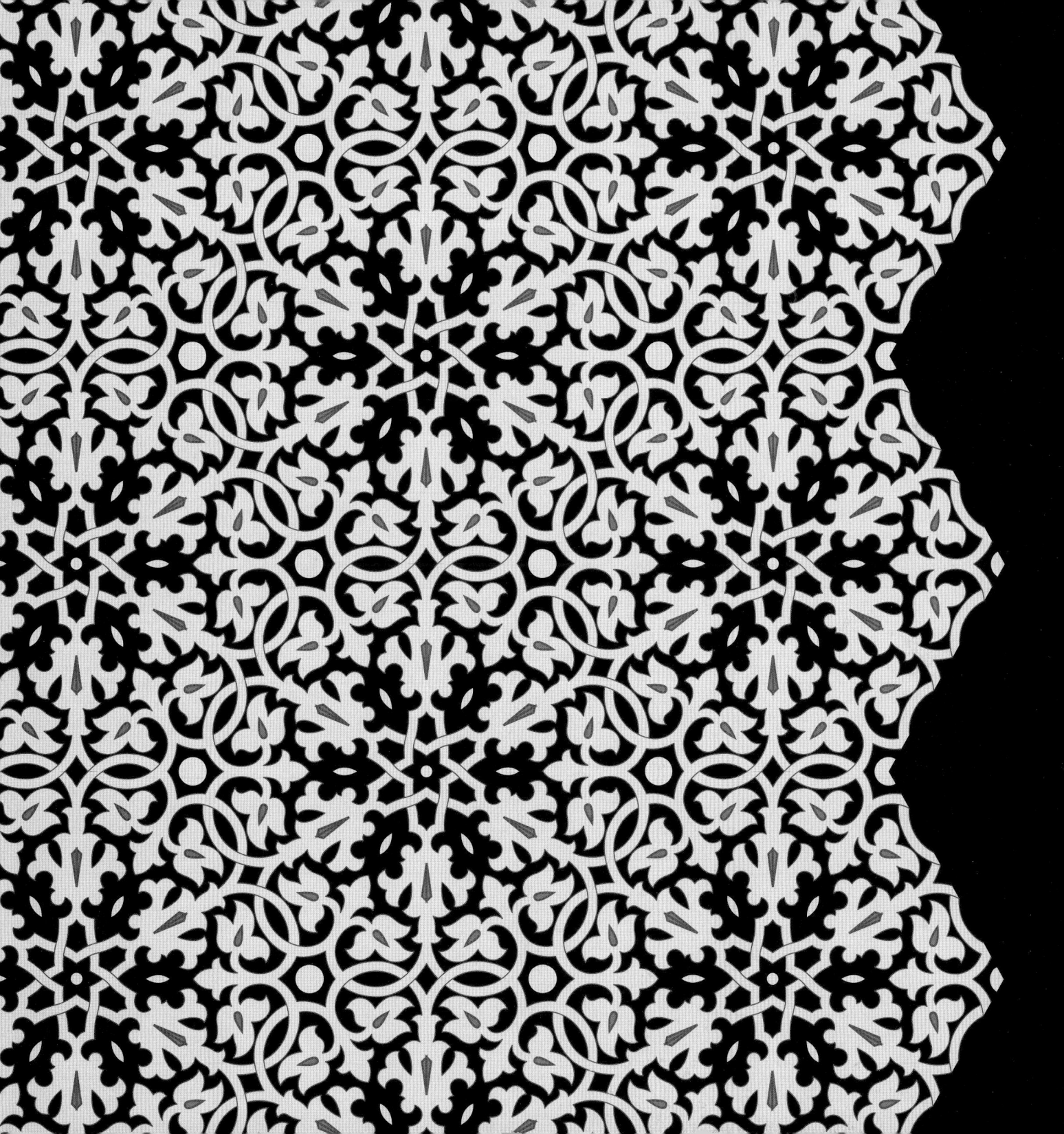

THE PEPIN PRESS / AGILE RABBIT EDITIONS

Cultural Styles
Elements of Chinese & Japanese Design
Chinese Patterns
Japanese Patterns
Japanese Papers
Indian Textile Prints
Ancient Mexican Designs
Turkish Designs
Persian Designs
Islamic Designs
Islamic Designs from Egypt
Arabian Geometric Patterns
Traditional Dutch Tile Designs
Barcelona Tile Designs
Tile Designs from Portugal
Havana Tile Designs

Historical Styles
Early Christian Patterns
Byzanthine Patterns
Mediæval Patterns
Gothic Patterns
Renaissance Patterns
Baroque Patterns
Rococo Patterns
Patterns of the 19th Century
Art Nouveau Designs
Jugendstil
Art Deco Designs
Fancy Designs 1920
Patterns of the 1930s

Picture Collections
Skeletons
Images of the Human Body
Bacteria And Other Micro Organisms
Erotic Images & Alphabets
5000 Animals (4 CDs)
Occult Images
Menu Designs

Photographs
Non Facturé - Rejected Photographs
Images of the Universe
Female Body Parts
Male Body Parts
Fruit
Vegetables
Flowers

Graphic Themes
Fancy Alphabets
Mini Icons
Signs & Symbols
1000 Decorated Initials
Graphic Frames
Graphic Ornaments
Compendium of Illustrations
Teknological
Biological
Geometric Patterns

Textile Patterns
Ikat Patterns
Batik Patterns
Weaving Patterns
Lace
Embroidery
Indian Textiles
Flower Power
European Folk Patterns
Kimono Patterns
Tapestry/Tapisserie

Miscellaneous
Floral Patterns
Wallpaper Designs
Paisley Patterns
Watercolour Patterns
Marbled Paper Designs
Historical & Curious Maps
Mythology Pictures
Astrology Pictures

Packaging & Folding
How To Fold
Folding Patterns
for Display & Publicity
Structural Package Designs
Mail It!
Special Packaging
Take One!

Web Design
Web Design Index 6
Web Design Index 7
Web Design Index by Content
Web Design Index by Content.02
Web Design Index by Content.03

Pepin Press Fashion Books
Bags
Spectacles & Sunglasses
Figure Drawing for Fashion Design
Wrap & Drape Fashion
Fashion Design 1800-1940
Art Deco Fashion
Traditional Henna Designs
Fashion Accessories
Hairstyles of the World

Pepin Press Art Books
Ethnic Jewellery
Crown Jewellery
Batik Design
Textiles of Java
The Straits Chinese
Decorated Paper Designs

More titles in preparation. In addition to the Agile Rabbit series of book +CD-ROM sets, The Pepin Press publishes a wide range of books on art, design, architecture, applied art, and popular culture.

Please visit www.pepinpress.com for more information.

COLOPHON

Copyright all illustrations and text
© 2007 Pepin van Roojen
All rights reserved

The Pepin Press | Agile Rabbit Editions
P.O. Box 10349
1001 EH Amsterdam, The Netherlands

Tel +31 20 420 20 21
Fax +31 20 420 11 52
mail@pepinpress.com
www.pepinpress.com

Design & text by Pepin van Roojen

Picture scanning and restoration by
Jakob Hronek

ISBN 978 90 5768 104 2

10 9 8 7 6 5 4 3 2 1
2012 11 10 09 08 07

Manufactured in Singapore

Introduction in English	5
Einführung auf Deutsch	7
Introduction en français	9
Introducción en español	11
Introduzione in italiano	13
Introdução em português	15
日本語による序文	17
中文前言	19

Free CD-Rom in the inside back cover

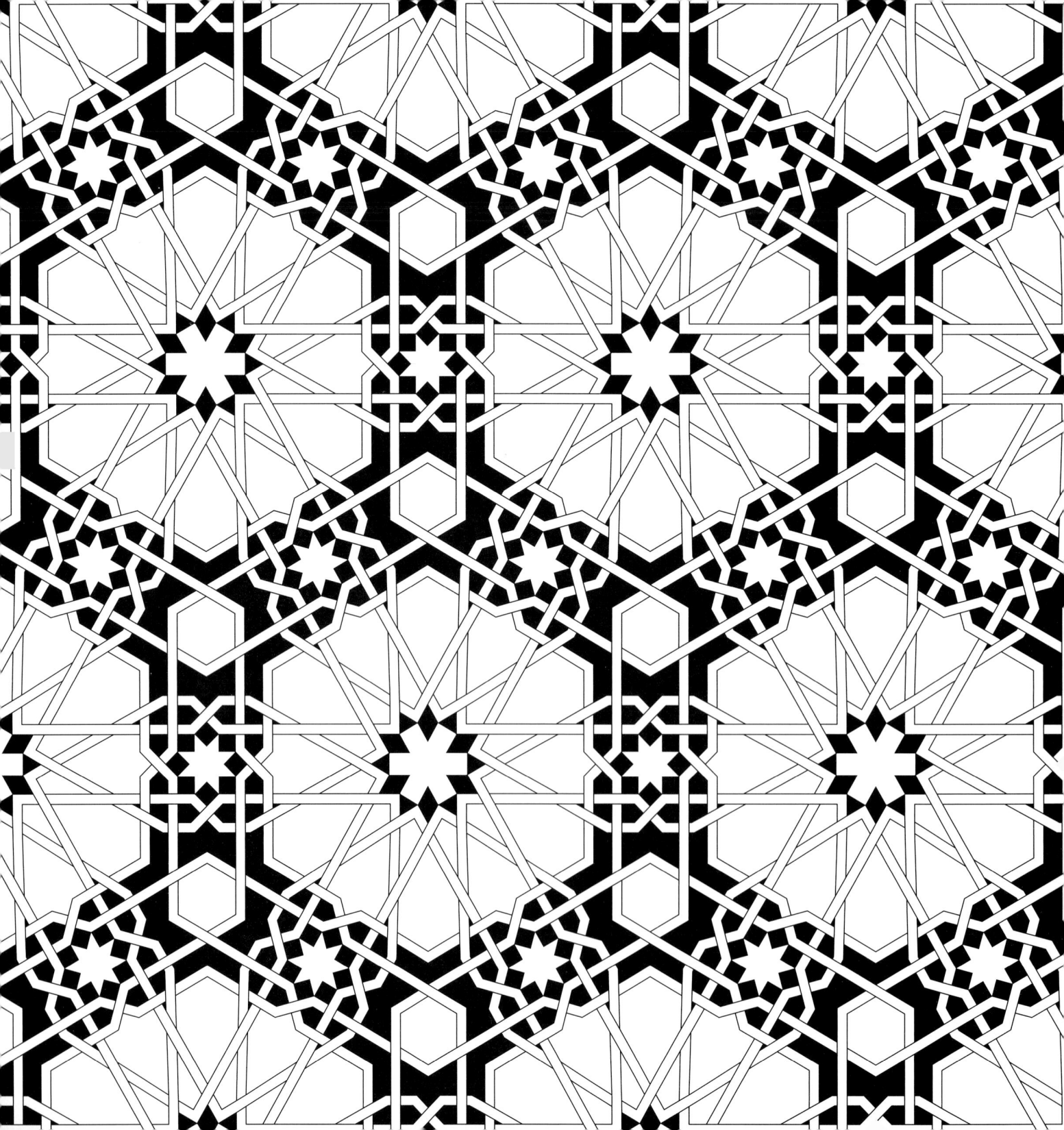

ISLAMIC DESIGNS FROM EGYPT

Intricate geometric patterns and Arabesque, a form of ornamentation based in vines and foliage, are among the principal expressions of Islamic decorative arts. In both forms of two dimensional decoration, Muslim artists have achieved exceptional levels of mastery, as can be seen in the decoration of some of the great mosques, mansions and other buildings in the two largest cities of Egypt: Cairo, the 'city of 1,000 minarets' and home to the world's greatest range of Islamic architecture, and Alexandria, Egypt's principal port city and ancient centre of learning.
The designs represented in this book have been culled from some of the magnificent buildings in these cities. All have been meticulously redrawn and digitised. In some cases, repeating patterns have been expanded to make them more suitable for graphic use, but of course the essence of the designs has been kept intact.

BOOK AND CD-ROM

The images in this book can be used as a graphic resource and for inspiration. All the illustrations are stored on the enclosed CD-ROM and are ready to use for printed media and web page design. The pictures can also be used to produce postcards, either on paper or digitally, or to decorate your letters, flyers, T-shirts, etc. They can be imported directly from the CD into most software programs. Some programs will allow you to access the images directly; in others, you will first have to create a document, and then import the images. Please consult your software manual for instructions.
The names of the files on the CD-ROM correspond with the page numbers in this book. The CD-ROM comes free with this book, but is not for sale separately. The files on Pepin Press/Agile Rabbit CD-ROMs are sufficiently large for most applications. However, larger and/or vectorised files are available for most images and can be ordered from The Pepin Press/Agile Rabbit Editions.

IMAGE RIGHTS

For non-professional applications, single images can be used free of charge. The images cannot be used for any type of commercial or otherwise professional application – including all types of printed or digital publications – without prior permission from The Pepin Press/Agile Rabbit Editions. Our permissions policy is very reasonable and fees charged, if any, tend to be minimal.

For inquiries about permissions and fees, please contact:
mail@pepinpress.com
Fax +31 20 4201152

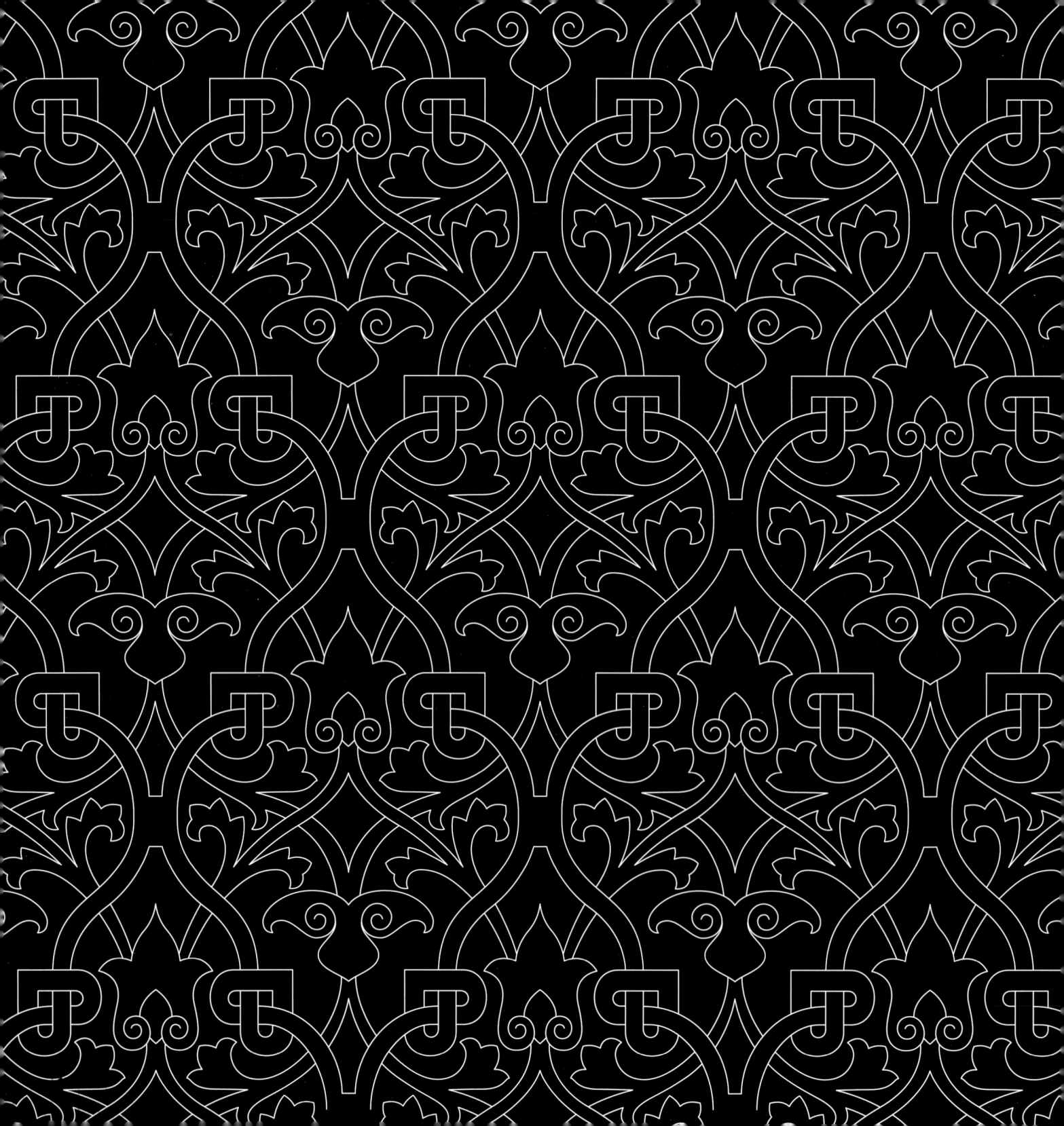

ISLAMISCHE MUSTER AUS ÄGYPTEN

Kunstvolle geometrische Muster und die Arabesque, ein ranken- oder blattförmiges Verzierungselement, zählen zu den bedeutendsten Ausdrucksformen islamischer Ornamentkunst. Auf beiden Gebieten dieser zweidimensionalen Ornamentik haben muslimische Künstler einen außergewöhnlichen Grad der Meisterschaft erreicht, der auch bei der Gestaltung der schönsten Moscheen, Häuser und anderer Bauwerke in den beiden größten Städten Ägyptens zum Ausdruck kommt – in Kairo, »Stadt der 1.000 Minarette« und Heimat einzigartiger islamischer Baukunst, und Alexandria, einst Zentrum antiker Geistesbildung und heute wichtigster Hafen des Landes. Die Designs in diesem Buch stammen von einigen der großartigsten Bauwerke in Kairo und Alexandria und sind mit größter Sorgfalt nachgezeichnet und digitalisiert. In Ausnahmefällen wurde ein sich wiederholendes Muster erweitert und so für grafische Anwendungen besser nutzbar gemacht, doch die Essenz des jeweiligen Entwurfs blieb selbstverständlich erhalten.

BUCH UND CD-ROM

Dieses Buch enthält Bilder, die als Ausgangsmaterial für grafische Zwecke oder als Anregung genutzt werden können. Alle Abbildungen sind auf der beiliegenden CD-ROM gespeichert und lassen sich direkt zum Drucken oder zur Gestaltung von Webseiten einsetzen. Sie können die Designs aber auch als Motive für Postkarten (auf Karton bzw. in digitaler Form) oder als Ornament für Ihre Briefe, Broschüren, T-Shirts usw. verwenden. Die Bilder lassen sich direkt von der CD in die meisten Softwareprogramme laden. Bei einigen Programmen lassen sich die Grafiken direkt einladen, bei anderen müssen Sie zuerst ein Dokument anlegen und können dann die jeweilige Abbildung importieren. Genauere Hinweise dazu finden Sie im Handbuch Ihrer Software.
Die Namen der Bilddateien auf der CD-ROM entsprechen den Seitenzahlen dieses Buchs. Die CD-ROM wird kostenlos mit dem Buch geliefert und ist nicht separat verkäuflich. Alle Bilddateien auf den CD-ROMs von The Pepin Press/Agile Rabbit wurden so groß dimensioniert, dass sie für die meisten Applikationen ausreichen; zusätzlich können jedoch größere Dateien und/oder Vektorgrafiken der meisten Bilder bei The Pepin Press/Agile Rabbit Editions bestellt werden.

BILDRECHTE

Einzelbilder dürfen für nicht-professionelle Anwendungen kostenlos genutzt werden; dagegen muss für die Nutzung der Bilder in kommerziellen oder sonstigen professionellen Anwendungen (einschließlich aller Arten von gedruckten oder digitalen Medien) unbedingt die vorherige Genehmigung von The Pepin Press/Agile Rabbit Editions eingeholt werden. Allerdings handhaben wir die Erteilung solcher Genehmigungen meistens recht großzügig und erheben – wenn überhaupt – nur geringe Gebühren.

Für Fragen zu Genehmigungen und Preisen wenden Sie sich bitte an:
mail@pepinpress.com
Fax +31 20 4201152

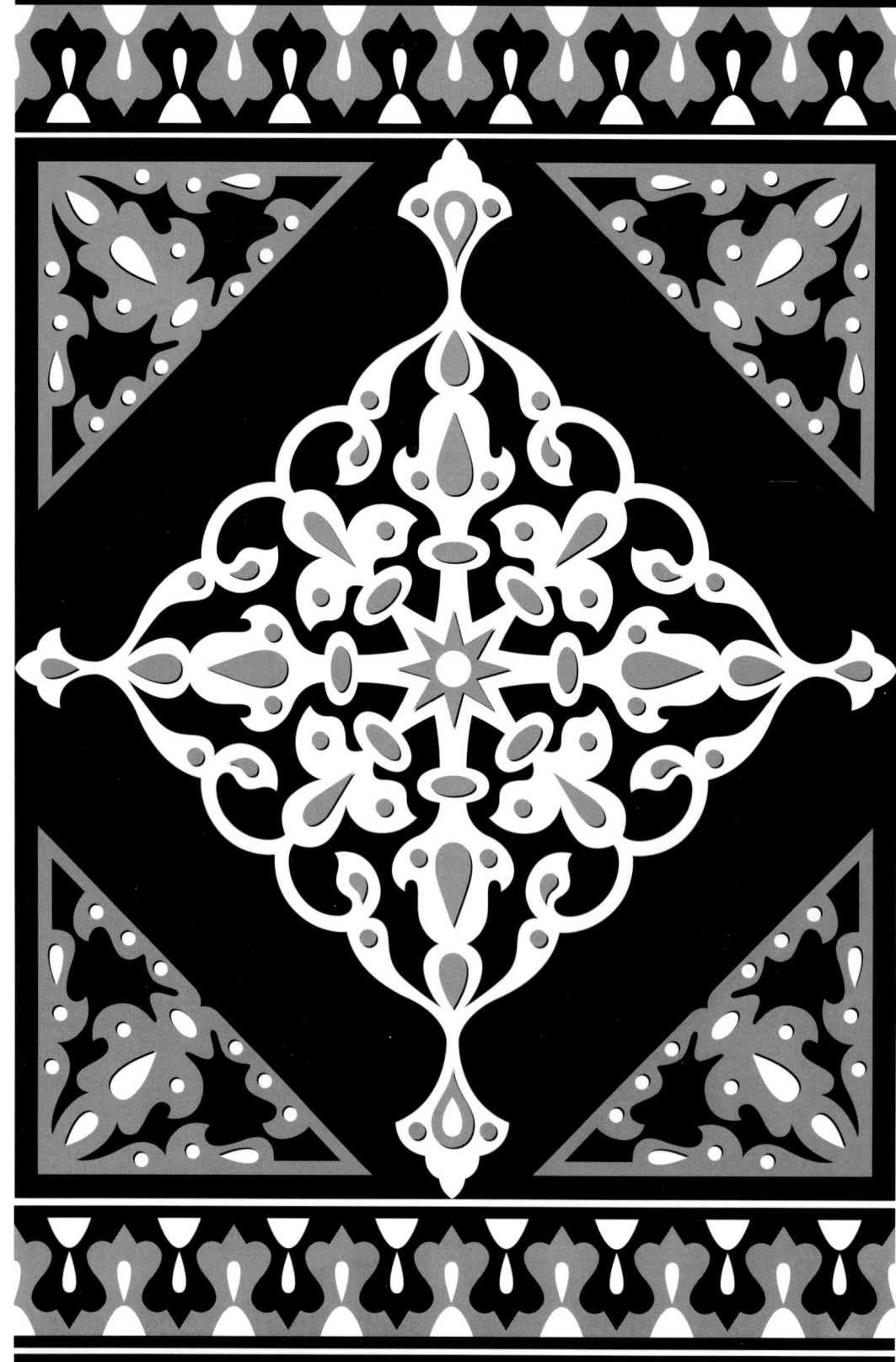

LES DESSINS ISLAMIQUES D'ÉGYPTE

Les modèles géométriques sophistiqués et l'arabesque, une forme de décoration qui s'inspire des plantes et de la vigne, figurent parmi les principales expressions de l'art décoratif islamique. Dans chacun de ces modèles de décoration sur deux dimensions, les artistes musulmans ont fait preuve d'une virtuosité exceptionnelle, notamment pour l'ornementation de certaines mosquées, demeures et autres édifices des deux plus grandes villes d'Égypte : le Caire, la « ville aux 1 000 minarets », qui abrite l'architecture islamique la plus variée du monde, et Alexandrie, la principale ville portuaire du pays et ancien foyer du savoir.
Les dessins représentés dans cet ouvrage ont été sélectionnés parmi certains des plus beaux bâtiments de ces villes. Ils ont tous été soigneusement redessinés et numérisés. Dans certains cas, des motifs répétitifs ont été multipliés afin de mieux les adapter à une utilisation graphique, mais l'essence des dessins a bien sûr été intégralement respectée.

LIVRE ET CD-ROM

Les images contenues dans ce livre peuvent servir de ressources graphiques ou de source d'inspiration. Toutes les illustrations sont stockées sur le CD-ROM ci-joint et sont prêtes à l'emploi sur tout support imprimé ou pour la conception de site Web. Elles peuvent également être employées pour créer des cartes postales, en format papier ou numérique, ou pour décorer vos lettres, prospectus, T-shirts, etc. Ces images peuvent être importées directement du CD dans la plupart des logiciels. Certaines applications vous permettent d'accéder directement aux images, tandis que d'autres requièrent la création préalable d'un document pour pouvoir les importer. Veuillez vous référer au manuel de votre logiciel pour savoir comment procéder.
Les noms des fichiers du CD-ROM correspondent aux numéros de page de cet ouvrage. Le CD-ROM est fourni gratuitement avec ce livre, mais ne peut être vendu séparément. Les fichiers des CD-ROM de The Pepin Press/Agile Rabbit sont d'une taille suffisamment grande pour la plupart des applications. Cependant, des fichiers plus grands et/ou vectorisés sont disponibles pour la plupart des images et peuvent être commandés auprès des éditions The Pepin Press/Agile Rabbit.

DROITS D'AUTEUR

Des images seules peuvent être utilisées gratuitement à des fins non professionnelles. Les images ne peuvent pas être employées à des fins commerciales ou professionnelles (y compris pour tout type de publication sur support numérique ou imprimé) sans l'autorisation préalable expresse des éditions The Pepin Press/Agile Rabbit. Notre politique d'autorisation d'auteur est très raisonnable et le montant des droits, le cas échéant, est généralement minime.

Pour en savoir plus sur les autorisations et les droits d'auteur, veuillez contacter :
mail@pepinpress.com
Fax +31 20 4201152

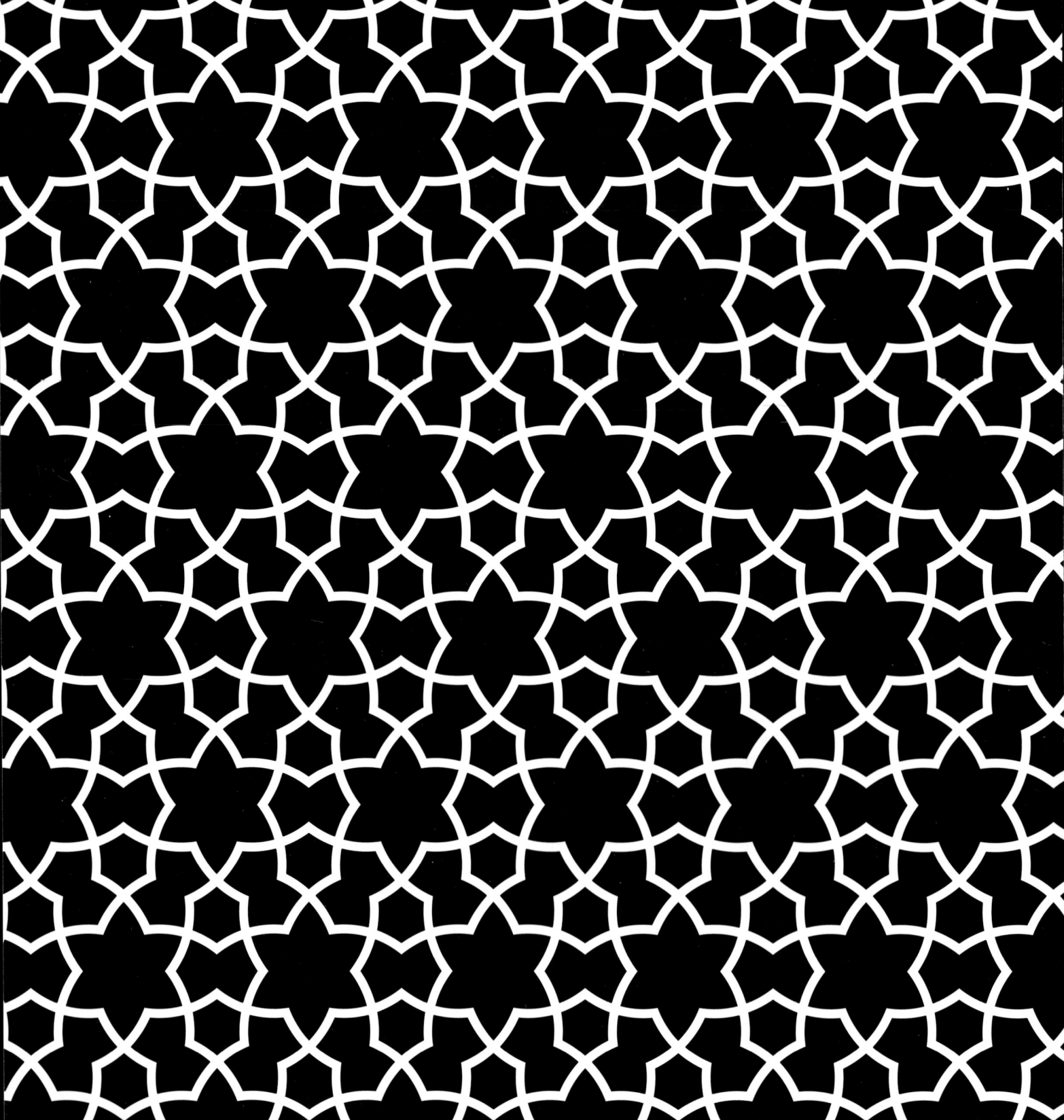

DISEÑOS ISLÁMICOS DE EGIPTO

Los estampados geométricos intrincados y los arabescos, una ornamentación a base de parras y follaje, figuran entre las principales expresiones de las artes decorativas islámicas. En ambas formas de decoración bidimensional, los artistas árabes han alcanzado unos niveles de maestría excepcionales, como demuestra la ornamentación de algunas de las grandes mezquitas, mansiones y otros edificios de las dos mayores metrópolis de Egipto: El Cairo, la «ciudad de los mil minaretes» y cuna del mayor despliegue mundial de arquitectura islámica, y Alejandría, la principal ciudad portuaria y excelso centro de sabiduría de la Antigüedad.
Los diseños ilustrados en este libro se han seleccionado de los edificios más magníficos de estas ciudades. Todos ellos se han redibujado y digitalizado de forma meticulosa. En algunos casos, los estampados repetitivos se han ampliado con el fin de hacerlos más adecuados para su uso gráfico, pero manteniendo siempre intacta la esencia de los diseños.

LIBRO Y CD-ROM

Este libro contiene imágenes que pueden servir como material gráfico o simplemente como inspiración. Todas las ilustraciones están incluidas en el CD-ROM adjunto y pueden utilizarse en medios impresos y diseño de páginas web. Las imágenes también pueden emplearse para crear postales, ya sea en papel o digitales, o para decorar sus cartas, folletos, camisetas, etc. Pueden importarse directamente desde el CD a diferentes tipos de programas. Algunas aplicaciones informáticas le permitirán acceder a las imágenes directamente, mientras que otras le obligarán a crear primero un documento y luego importarlas. Consulte el manual de software pertinente para obtener instrucciones al respecto.
Los nombres de los archivos contenidos en el CD-ROM se corresponden con los números de página del libro. El CD-ROM se suministra de forma gratuita con el libro. Queda prohibida su venta por separado. Los archivos incluidos en los discos CD-ROM de Pepin Press/Agile Rabbit tienen una resolución suficiente para su uso con la mayoría de aplicaciones. Sin embargo, si lo precisa, puede encargar archivos con mayor definición y/o vectorizados de la mayoría de las imágenes a The Pepin Press/Agile Rabbit Editions.

DERECHOS SOBRE LAS IMÁGENES

Para aplicaciones no profesionales, pueden emplearse imágenes sueltas sin coste alguno. Estas imágenes no pueden utilizarse para fines comerciales o profesionales (incluido cualquier tipo de publicación impresa o digital) sin la autorización previa de The Pepin Press/Agile Rabbit Editions. Nuestra política de permisos es razonable y las tarifas impuestas tienden a ser mínimas.

Para solicitar información sobre autorizaciones y tarifas, póngase en contacto con:
mail@pepinpress.com
Fax +31 20 4201152

DESIGN ISLAMICI DALL'EGITTO

Intricati disegni geometrici e arabesque, una forma ornamentale basata su viti e fogliame, sono fra le espressioni principali delle arti decorative islamiche. In tutte e due le forme di decorazione bidimensionale, gli artisti islamici hanno raggiunto dei livelli eccezionali di maestria, come si può osservare nelle decorazioni di alcune delle più grandi moschee, magioni e altri edifici in due città dell'Egitto: il Cairo, la 'città dei 1.000 minareti' ed il luogo con la piu' ampia gamma di architettura islamica al mondo, e Alessandria, la città porto principale dell'Egitto e antico centro educativo.
I design rappresentati in questo libro sono stati scovati in alcuni degli edifici più meravigliosi di queste città. Tutti sono stati meticolosamente ridisegnati e digitalizzati. In alcuni casi, dei disegni ripetitivi sono stati espansi per renderli più adatti all'uso grafico, ma ovviamente l'essenza dei disegni è stata conservata.

LIBRO E CD ROM

Le immagini in questo libro possono essere utilizzate come risorsa grafica e come ispirazione. Tutte le illustrazioni sono salvate sul CD ROM incluso e sono pronte all'uso per la stampa ed il design di pagine web. Le immagini possono anche essere utilizzate per produrre delle cartoline, in forma stampata o digitale, o per decorare le vostre lettere, volantini, magliette, eccetera. Possono essere direttamente riprodotte dal CD nella maggior parte dei programmi software. Alcuni programmi vi permetteranno l'accesso diretto alle immagini; in altri, dovrete prima creare un documento, e poi importare le immagini. Consultate per favore il manuale del vostro software per ulteriori istruzioni. I nomi dei file sul CD ROM corrispondono ai numeri di pagina in questo libro. Il CD ROM viene fornito gratis con questo libro, ma non è in vendita separatamente. I file sui CD ROM della Pepin Press/Agile Rabbit sono di dimensione adatta per la maggior parte delle applicazioni. Comunque file più grandi o vettoriali sono disponibili per la maggior parte delle immagini e possono essere ordinati dalla Pepin Press/Agile Rabbit Editions.

DIRITTI D'IMMAGINE

Per applicazioni non-professionali, delle singole immagini possono essere utilizzate senza costi aggiuntivi. Le immagini non possono essere utilizzate per nessun tipo di applicazione commerciale o professionale – compresi tutti i tipi di pubblicazioni stampate e digitali – senza previo permesso dalla Pepin Press/Agile Rabbit Editions. La nostra gestione delle autorizzazioni è estremamente ragionevole e le tariffe addizionali applicate, qualora ricorrano, sono minime.

Per ulteriori domande riguardo le autorizzazioni e le tariffe, contattateci per favore:
mail@pepinpress.com
Fax +31 20 4201152

DESENHOS ISLÂMICOS DO EGIPTO

Padrões geométricos intrincados e *Arabescos*, uma forma de ornamentação baseada em vinhas e folhagem, estão entre as principais expressões das artes decorativas islâmicas. Em ambas as formas da decoração bidimensional, os artistas muçulmanos atingiram níveis de mestria excepcionais, como pode ser visto na decoração de algumas das grandes mesquitas, mansões e outros edifícios das duas maiores cidades do Egipto: Cairo, a «cidade dos mil minaretes» e local da maior variedade de arquitectura islâmica do mundo, e Alexandria, a principal cidade portuária do Egipto e antigo centro de ensino.

Os desenhos representados neste livro foram retirados de alguns dos magníficos edifícios dessas cidades. Todos foram meticulosamente desenhados e digitalizados. Em alguns casos, a repetição dos padrões foi alargada para que a sua utilização gráfica fosse mais fácil, mas obviamente, a essência dos desenhos manteve-se intacta.

LIVRO E CD-ROM

As imagens neste livro podem ser usadas como recurso gráfico e fonte de inspiração. Todas as ilustrações estão guardadas no CD-ROM incluído e prontas a serem usadas em suportes de impressão e design de páginas web. As imagens também podem ser usadas para produzir postais, tanto em papel como digitalmente, ou para decorar cartas, brochuras, T-shirts e outros artigos. Podem ser importadas directamente do CD para a maioria dos programas de software. Alguns programas permitem aceder às imagens directamente, enquanto que noutros, terá de primeiro criar um documento para poder importar as imagens. Consulte o manual do software para obter instruções.

Os nomes dos ficheiros no CD-ROM correspondem aos números de páginas no livro. O CD-ROM é oferecido gratuitamente com o livro, mas não pode ser vendido separadamente. A dimensão dos ficheiros nos CD-ROMs da Pepin Press/Agile Rabbit é suficiente para a maioria das aplicações. Contudo, os ficheiros maiores e/ou vectorizados estão disponíveis para a maioria das imagens e podem ser encomendados junto da Pepin Press/Agile Rabbit Editions.

DIREITOS DE IMAGEM

Podem ser usadas imagens individuais gratuitamente no caso de utilizações não profissionais. As imagens não podem ser usadas para qualquer tipo de utilização comercial ou profissional, incluindo todos os tipos de publicações digitais ou impressas, sem autorização prévia da Pepin Press/Agile Rabbit Editions. A nossa política de autorizações é muito razoável e as tarifas cobradas, caso isso se aplique, tendem a ser bastante reduzidas.

Para esclarecimentos sobre autorizações e tarifas, queira contactar:
mail@pepinpress.com
Fax +31 20 4201152

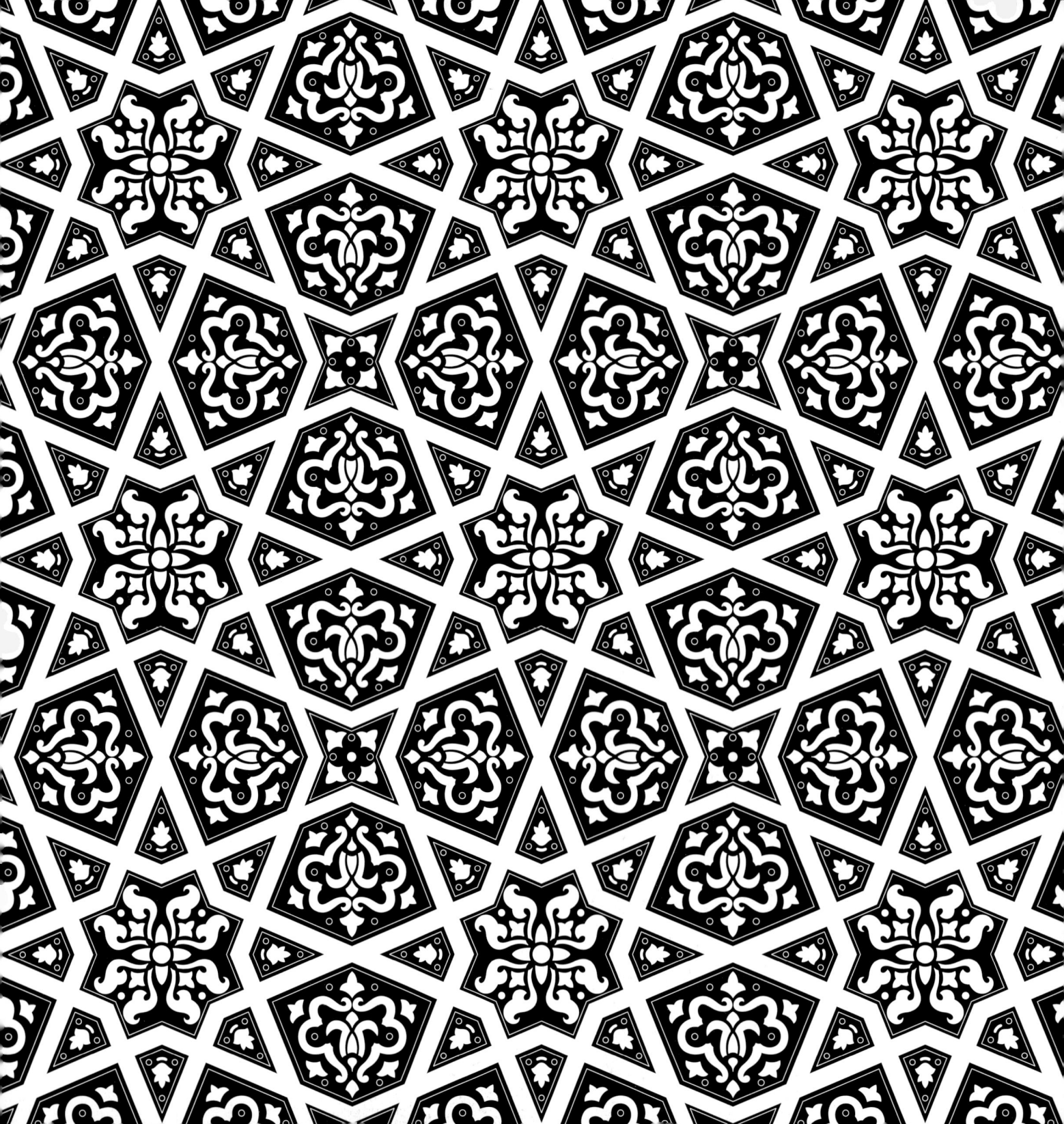

エジプトのイスラム・デザイン

凝った幾何学模様とアラベスク模様は、植物のつると葉をモチーフにし、イスラム文化の装飾アートにおいてもっとも多く用いられている様式です。イスラムのアーティストたちによって究められたこの二次元装飾様式は、エジプトの２大都市であるカイロとアレキサンドリアの有名なモスクや邸宅、ビルに残っています。「千の尖塔の街」と呼ばれるカイロには、世界屈指のイスラム建築物があります。アレキンドリアはエジプト一の海港都市で、古代には学問の中心地でした。

本書に収録されているイスラム・デザインは、この２大都市の壮麗な建築物に用いられているものを、細部にわたって正確に再現し、デジタル化しました。グラフィック・デザインに使用しやすいように、同じ模様をコピー拡張したものもありますが、各デザインのエッセンスはそのままです。

本とCD-ROM

本書に掲載されているデザインは、グラフィック・デザインの参考にしたり、インスピレーションの材料に使えます。本書に掲載されているすべてのイラストは、附録のCD-ROMに収録されています。印刷媒体やウェブデザイン、絵はがき、レター、チラシ、Tシャツなどの作成に利用できます。たいていのソフトウエア・プログラムについて、CD-ROMから直接インポート可能です。直接イメージにアクセスできない場合には、まず、ファイルを作成し、ご使用になりたいイメージをインポートすれば簡単です。インポートの方法などの詳細については、ソフトウエアのマニュアルをご参照ください。

CD-ROMの各ファイル名は、本書のページ番号になっています。このCD-ROMは本書の附録であり、CD-ROMのみの販売はいたしておりません。ペピン・プレス／アジャイレ・ラビットのCD-ROM収録のファイルは、たいていのアプリケーションに対応できるサイズです。もっと大きなサイズのファイル、あるいはベクトル化されたファイルをご希望の方は、ザ・ペピン・プレス／アジャイレ・ラビット・エディションズあてにオーダーしてください。

イメージの版権について

イメージを非営利目的で１度使用する場合には、版権料はかかりません。印刷媒体、デジタル媒体を含み、業務や営利目的で使用する場合には、事前にザ・ペピン・プレス／アジャイレ・ラビット・エディションズから許可を得ることが必要です。版権料に関する弊社の方針は良心的です。版権料が派生する場合でも良心的な料金です。

使用許可と版権料についてのお問い合わせは下記にお願いします。
mail@pepinpress.com
ファクス:31 20 4201152

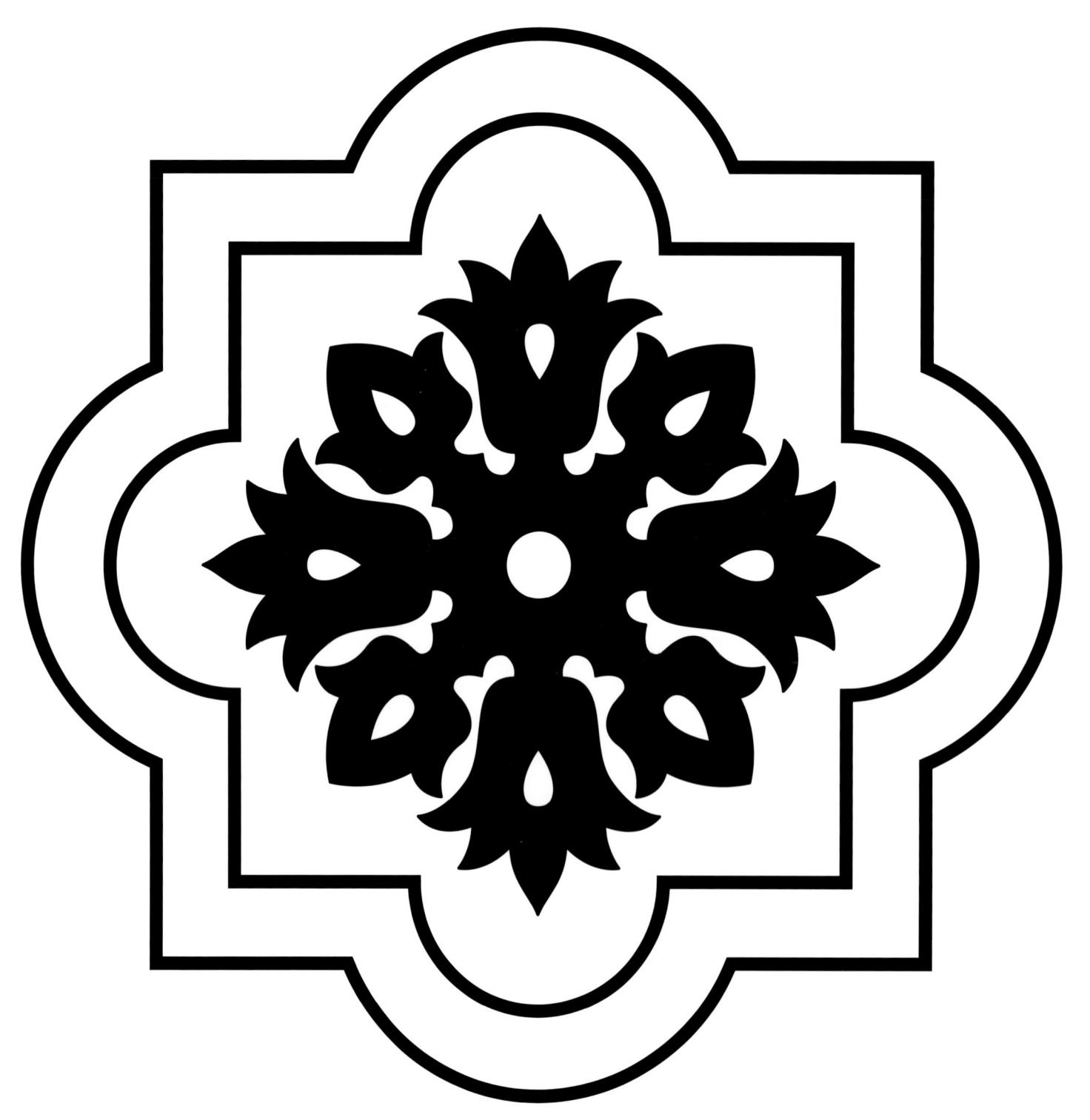

埃及的伊斯兰设计

复杂的几何图案和阿拉伯式图饰，一种基于藤蔓和植物的装饰格式是伊斯兰装饰艺术的主要表达方式。在这两种空间装饰形式中，穆斯林艺术家达到了异常高超的水平，这可以从位于埃及两座最大的城市--开罗，拥有一千座尖塔和作为世界伊斯兰建筑之乡的城市，和亚历山大，埃及的主要港口城市和古代教育中心--的一些宏伟的清真寺，大厦和其它建筑的装饰中发现出来。

在这本书中所代表的设计是从这些城市中的宏大建筑中精选出来的。所有设计进行了精心的重绘并进行了数字化处理。在一些情况下，对重复图案进行了扩展，目的是使它们更适于图形使用，但是，这并没有触及设计的核心。

书和光盘

此书的图片可以作为图形资源和灵感源泉予以使用。所有配图都存储在所附的光盘中，并且随时可用于打印媒介和网页设计。图画可以用于制作纸质或数字化的明信片；或者用于装饰你的信件，传单和T恤衫。它们可以直接从光盘中输入到多数软件程序中。一些程序可以使你直接登录图片，另外，你可以首先创设一个文件，然后输入图片。请参考你的软件手册中的指示。
光盘中文件名称同此书的页码相对应。光盘随此书免费赠送，但不得单独用于销售。Pepin出版社/灵兔光盘上的文件相当庞大，足以适合多数应用。但是，我们可以提供更大和/或矢量化文件，但需要从Pepin出版社/灵兔版本(The Pepin Press /Agile Rabbit Editions)进行定购。

图片权利

单个图片可以出于非专业用途免费予以使用，但在未经Pepin出版社/灵兔版本事先许可的情况下，图片不得出于任何类型的商业或其它专业用途予以使用，包括所有类型的打印或数字化出版物。我们的许可政策是十分合理的并且是有偿的，如果是有偿的，一般是最低限度的收费。

对于许可和收费，如有任何疑问，请联系：
mail@pepinpress.com
传真： +31 20 4201152

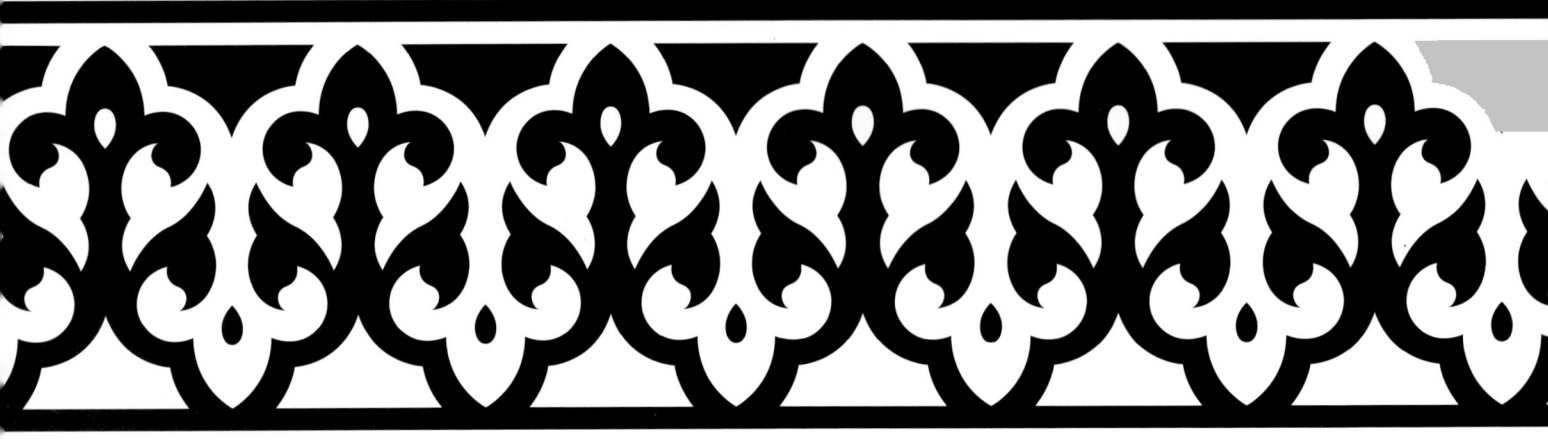

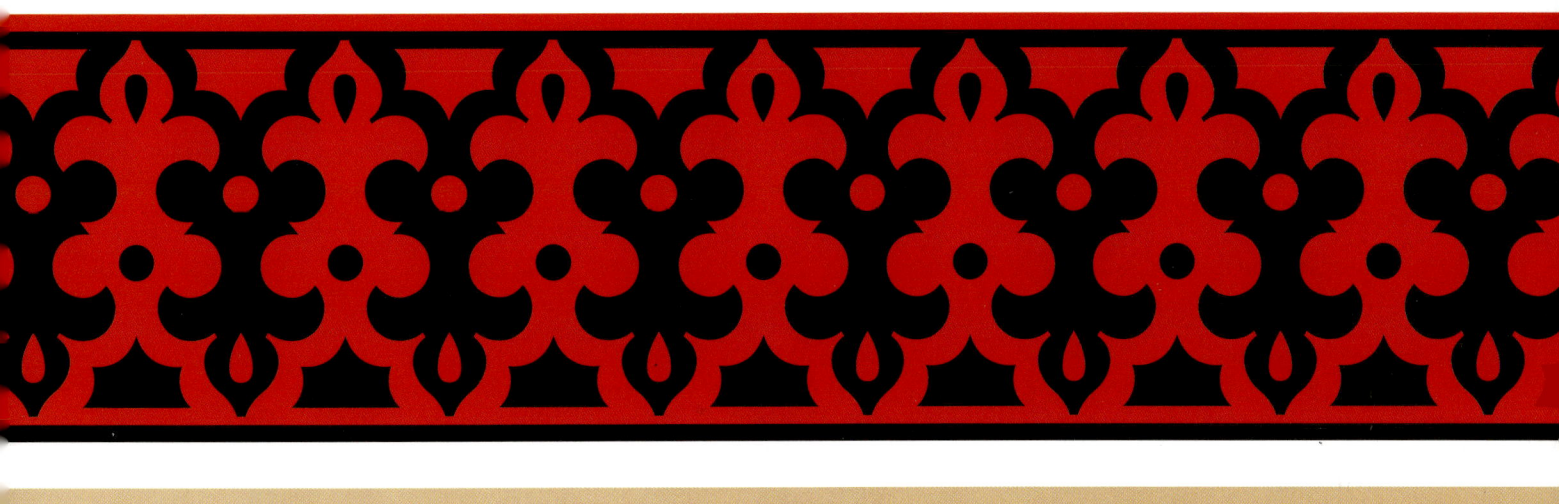
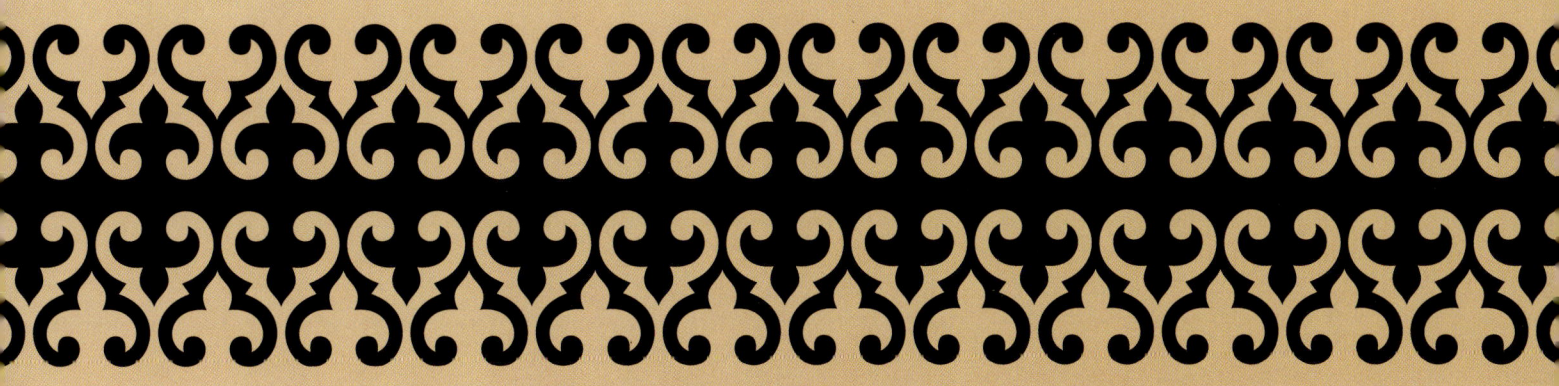
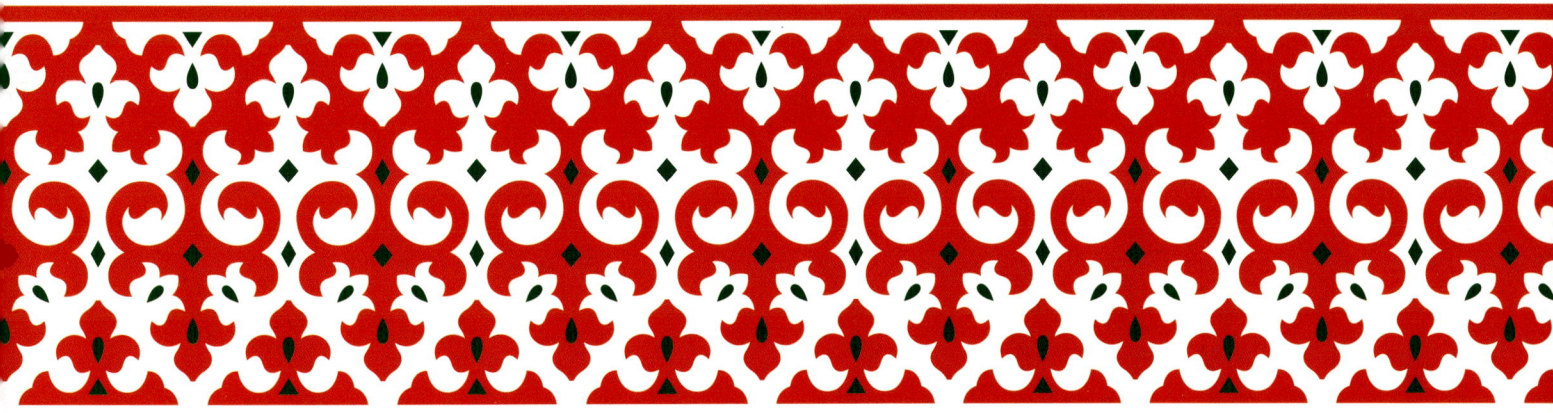

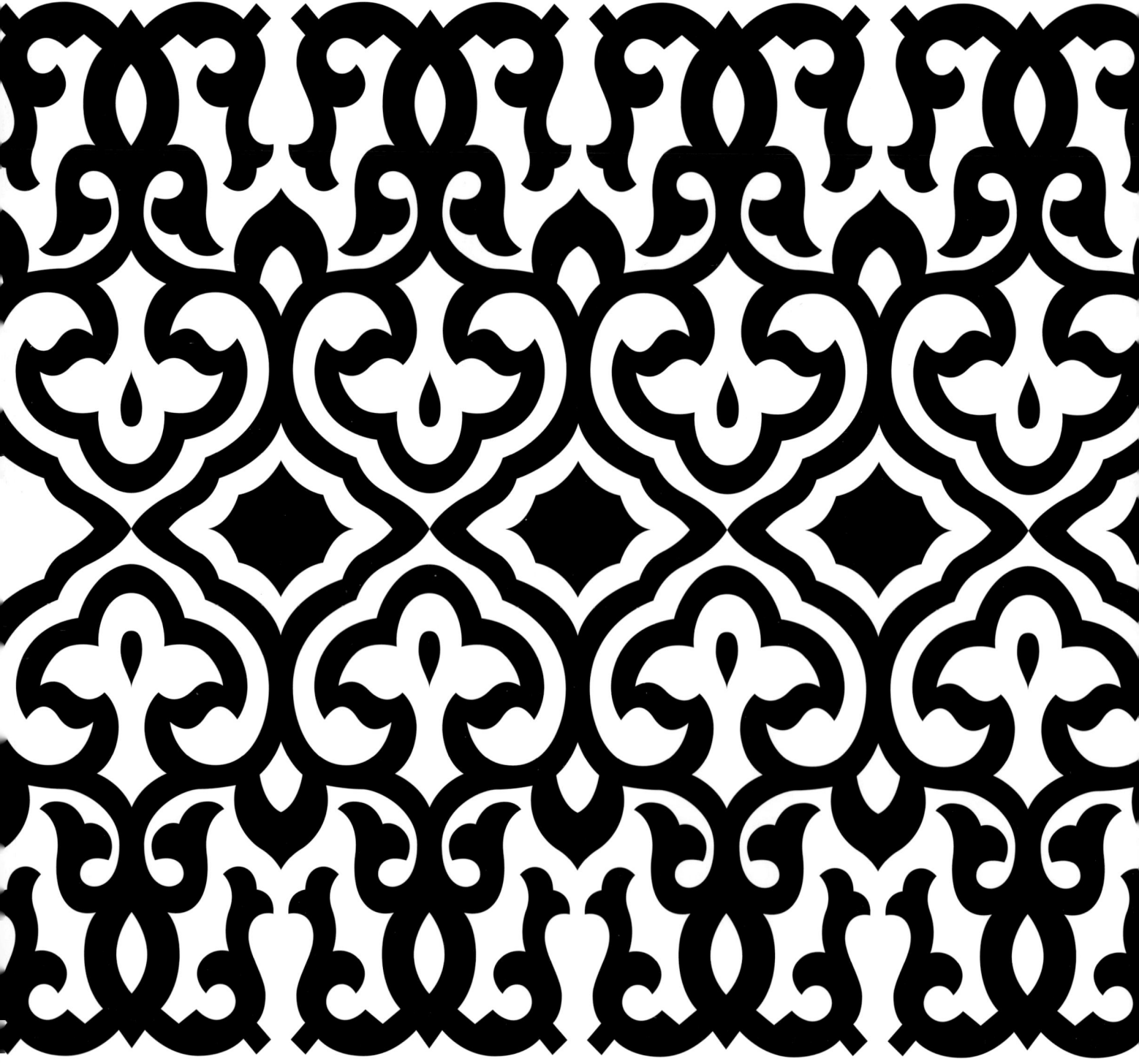

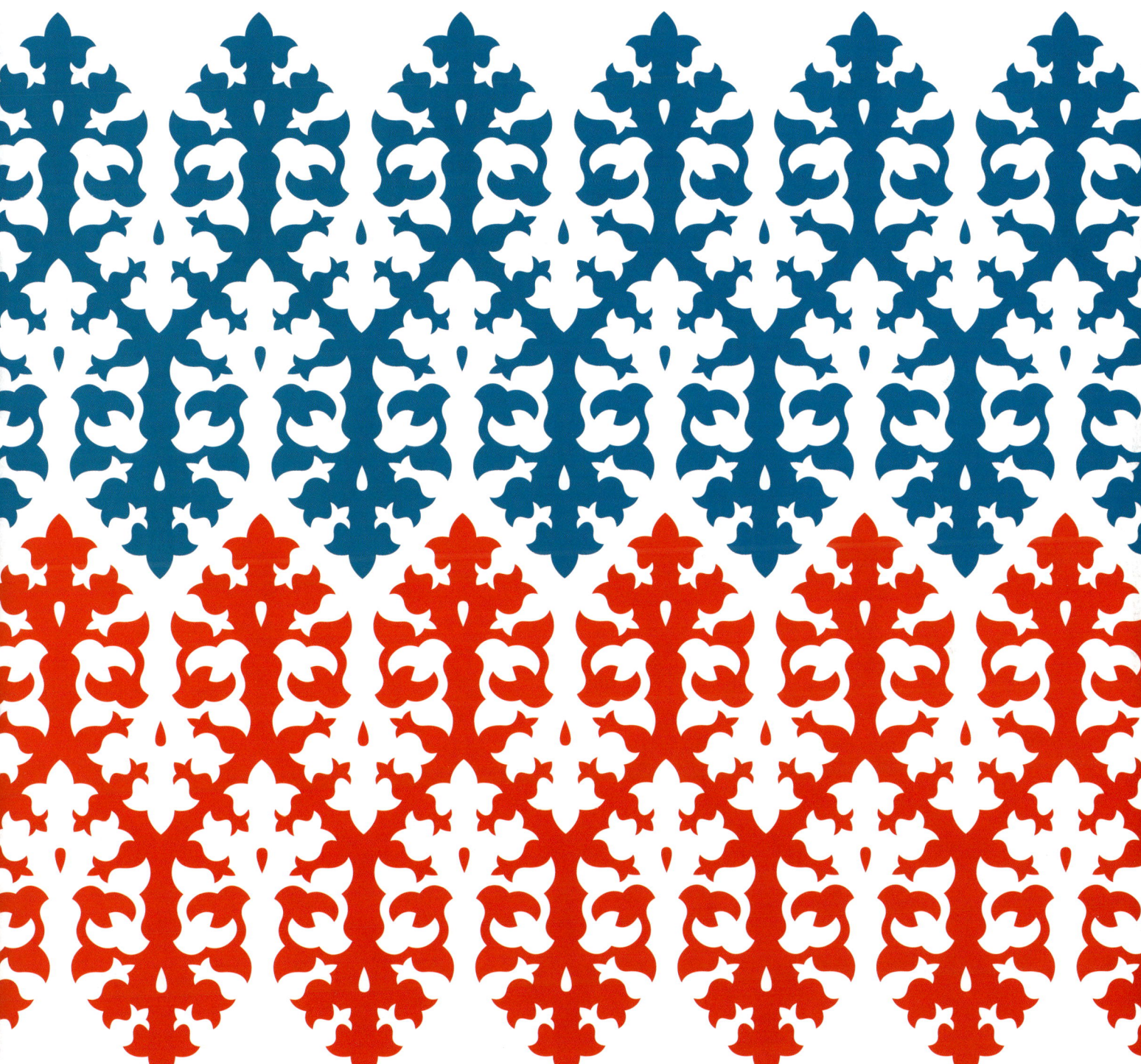

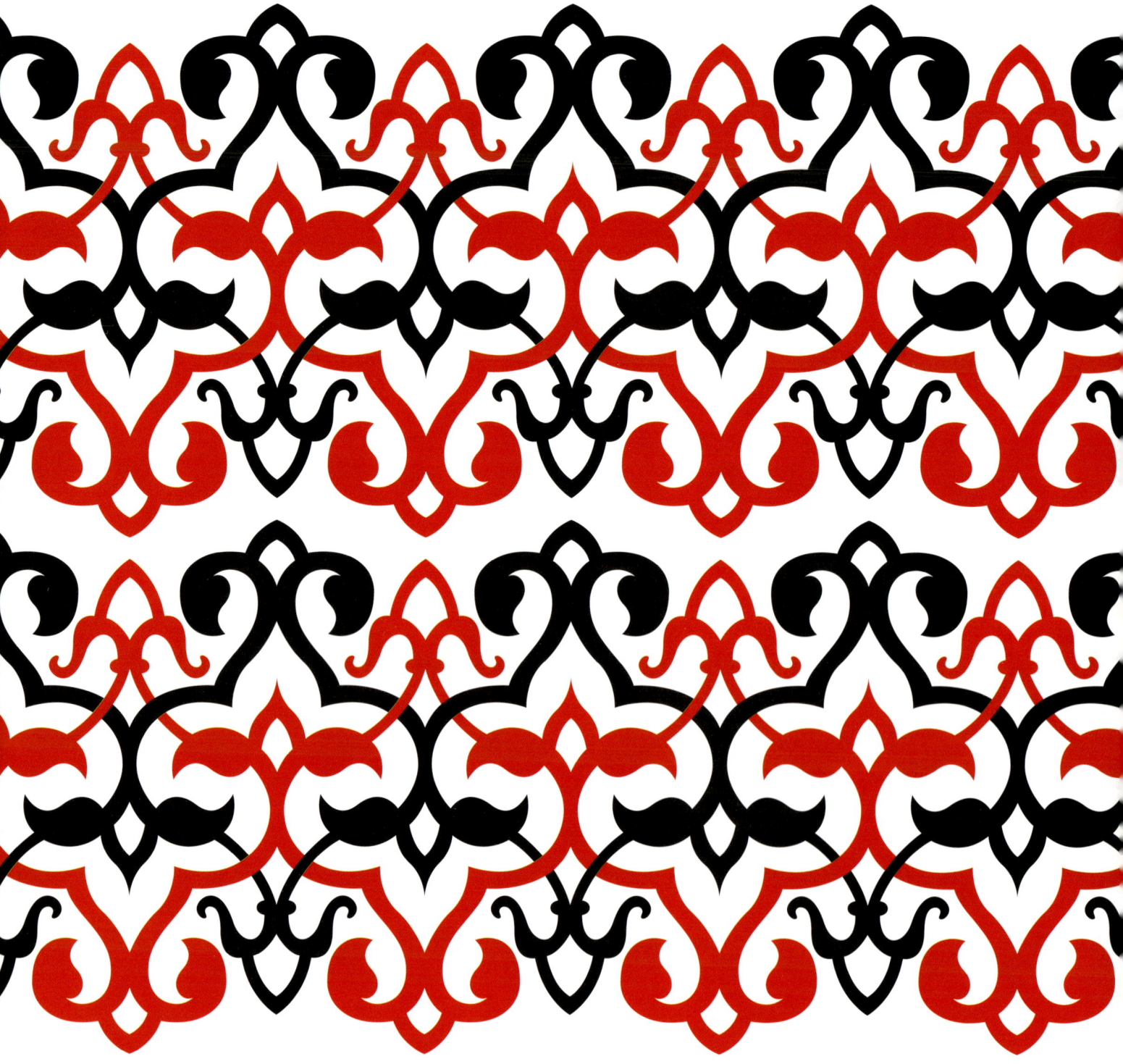

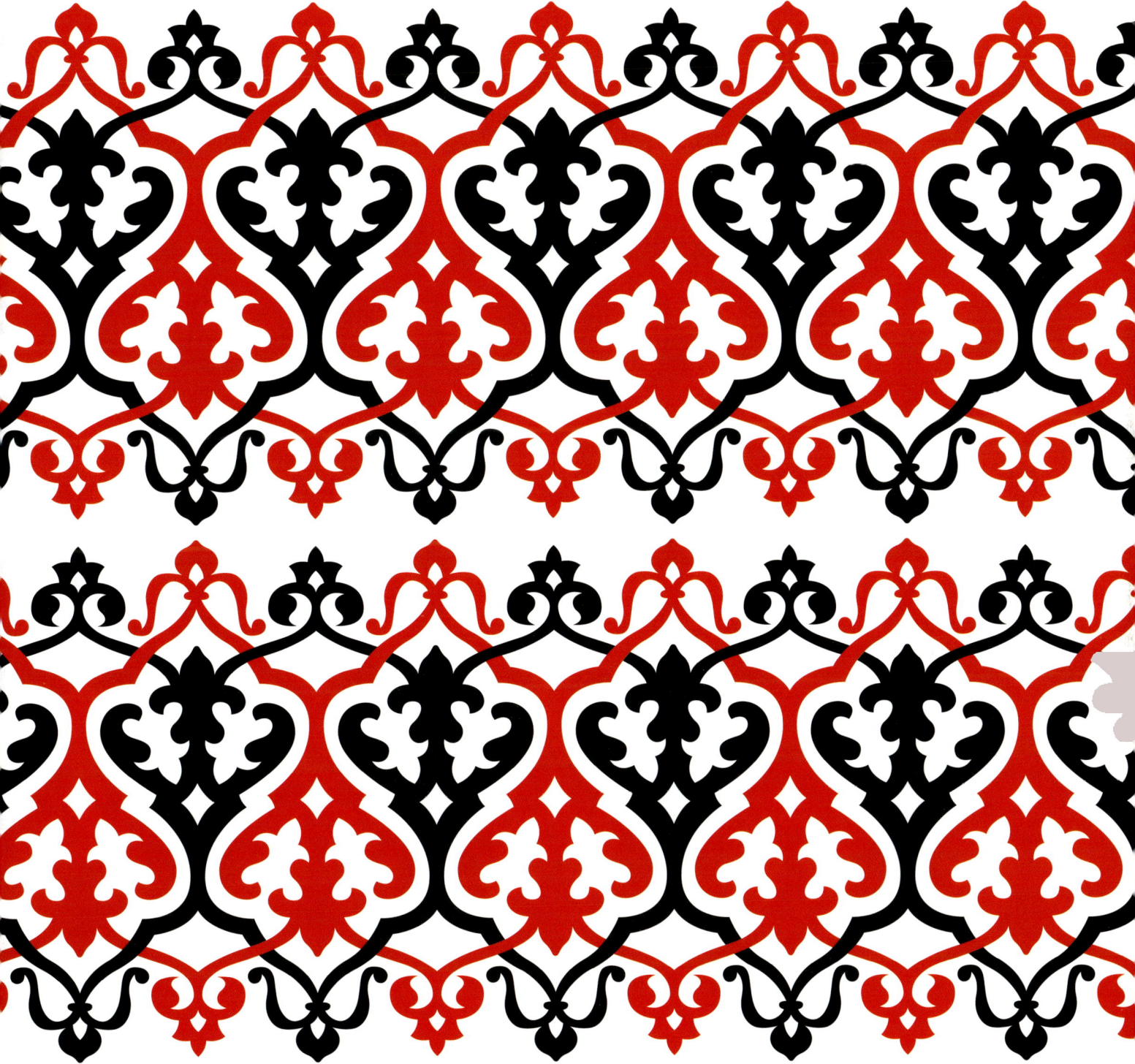

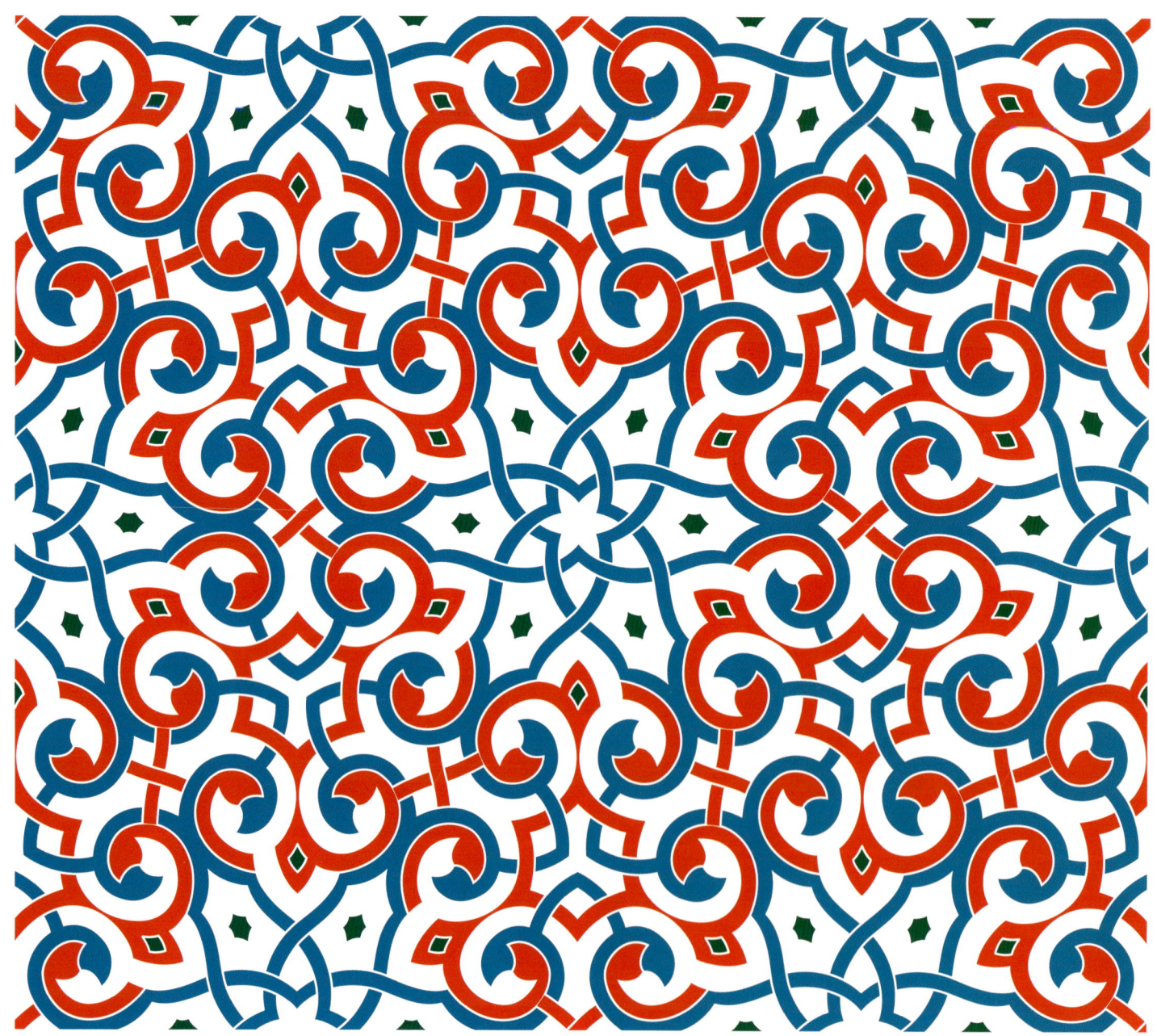

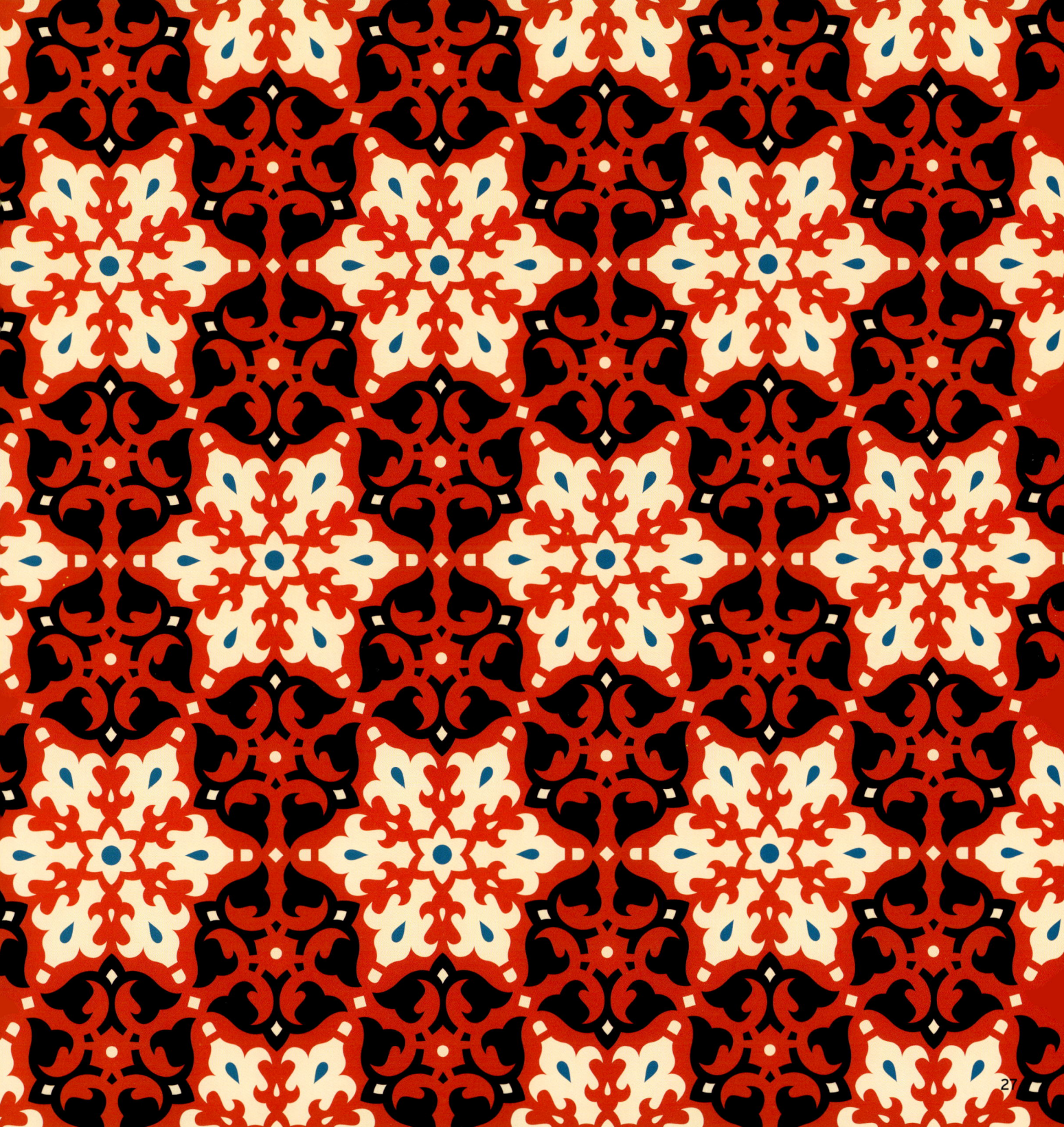

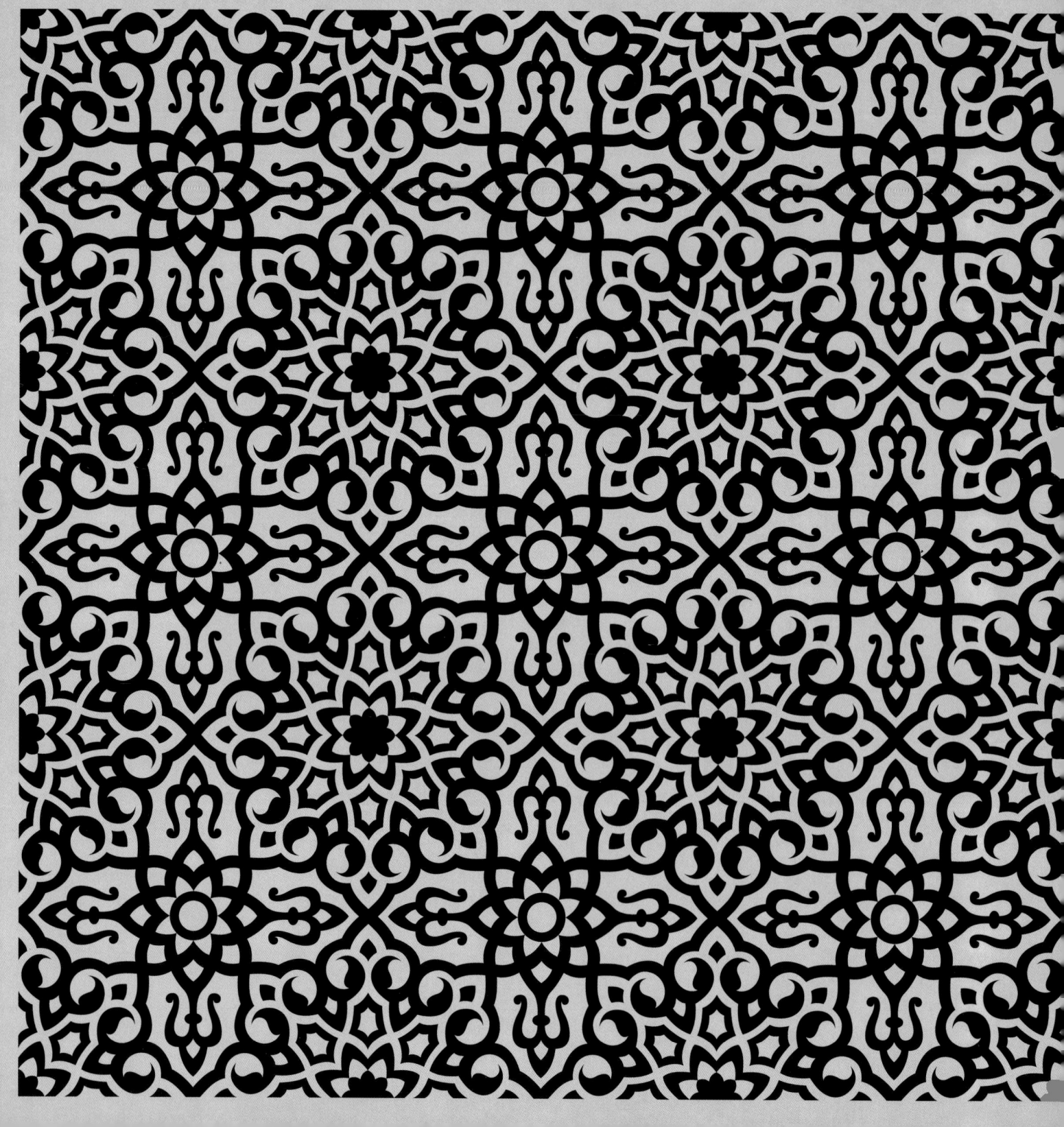

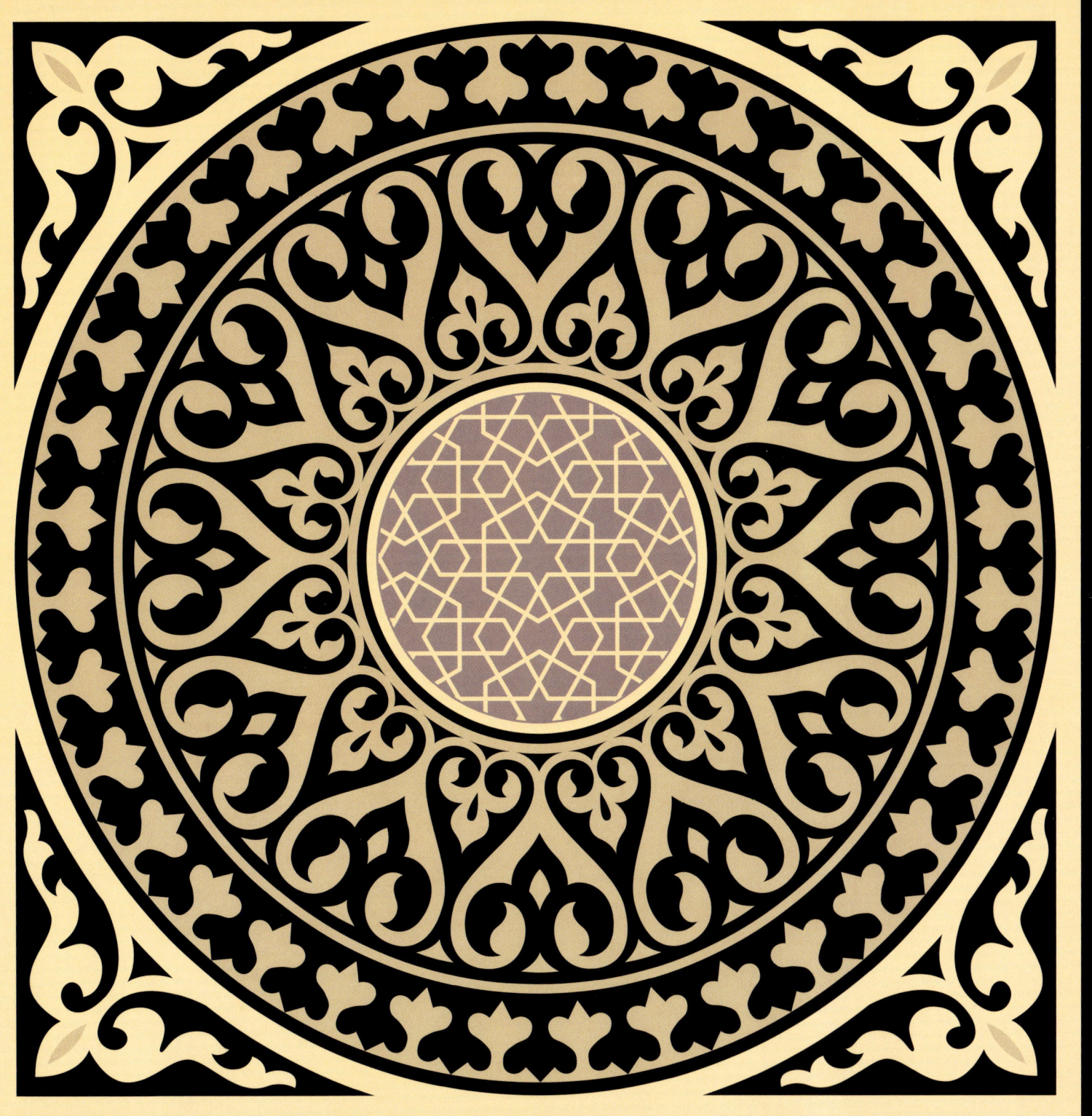

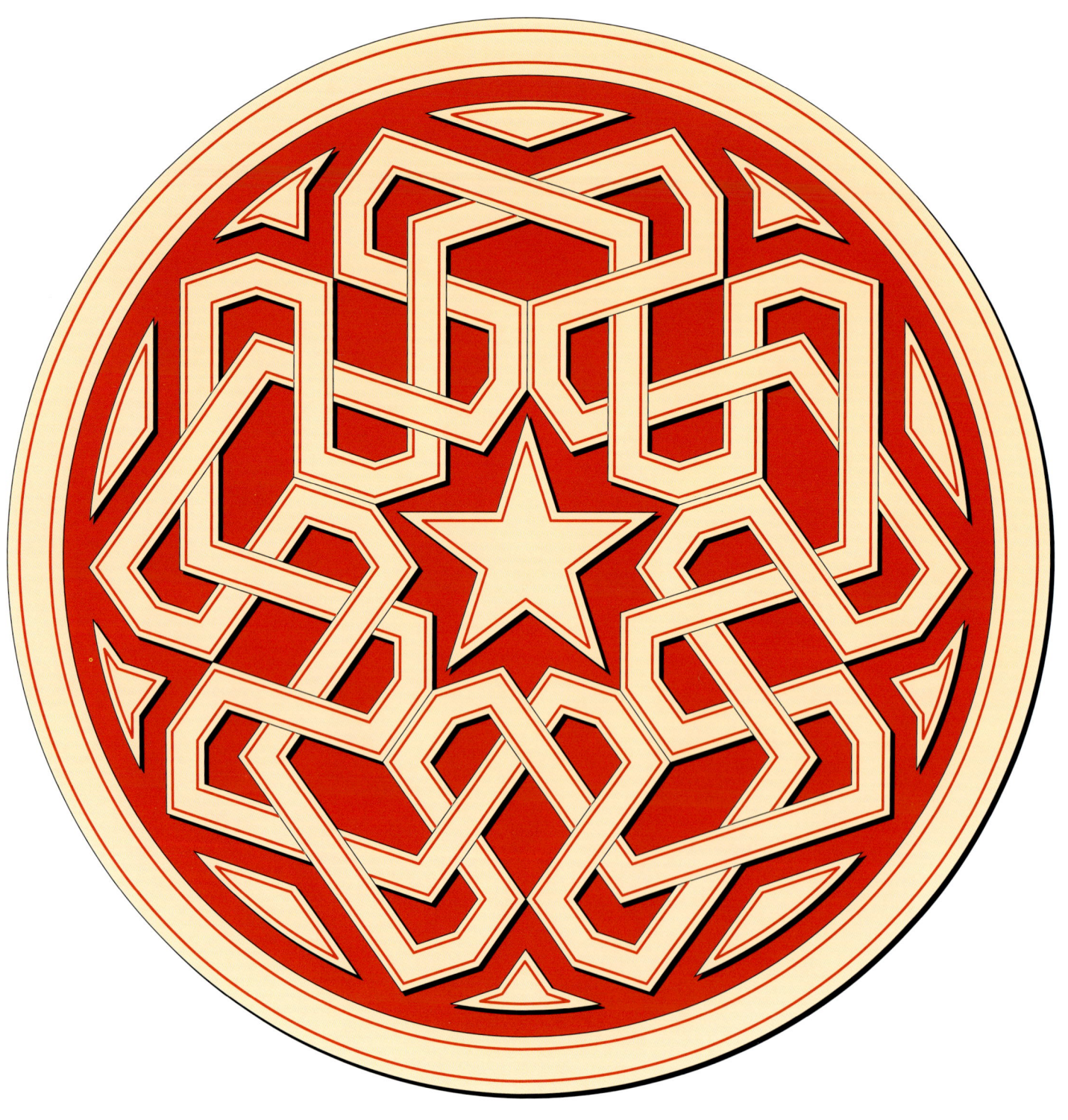

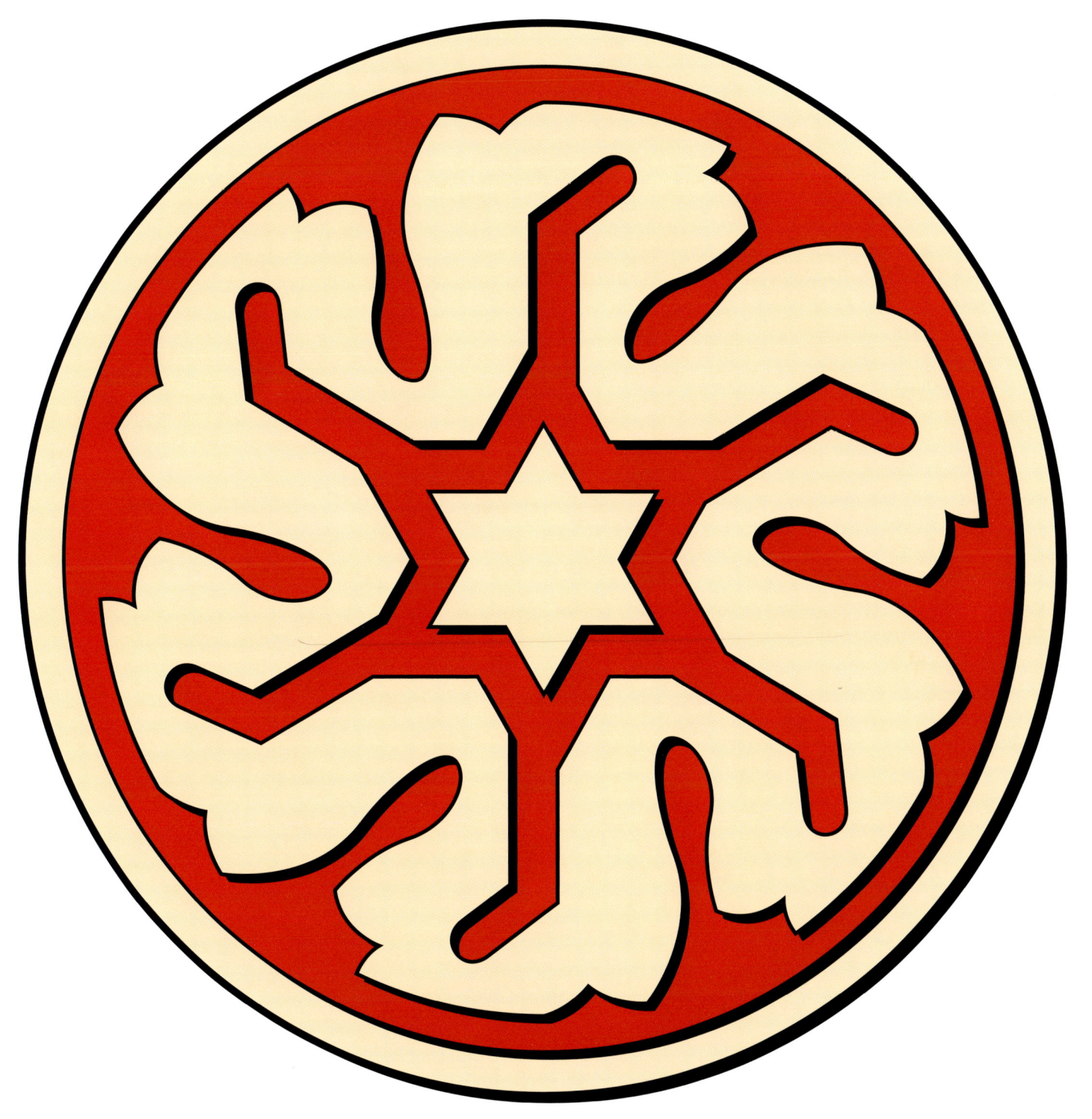

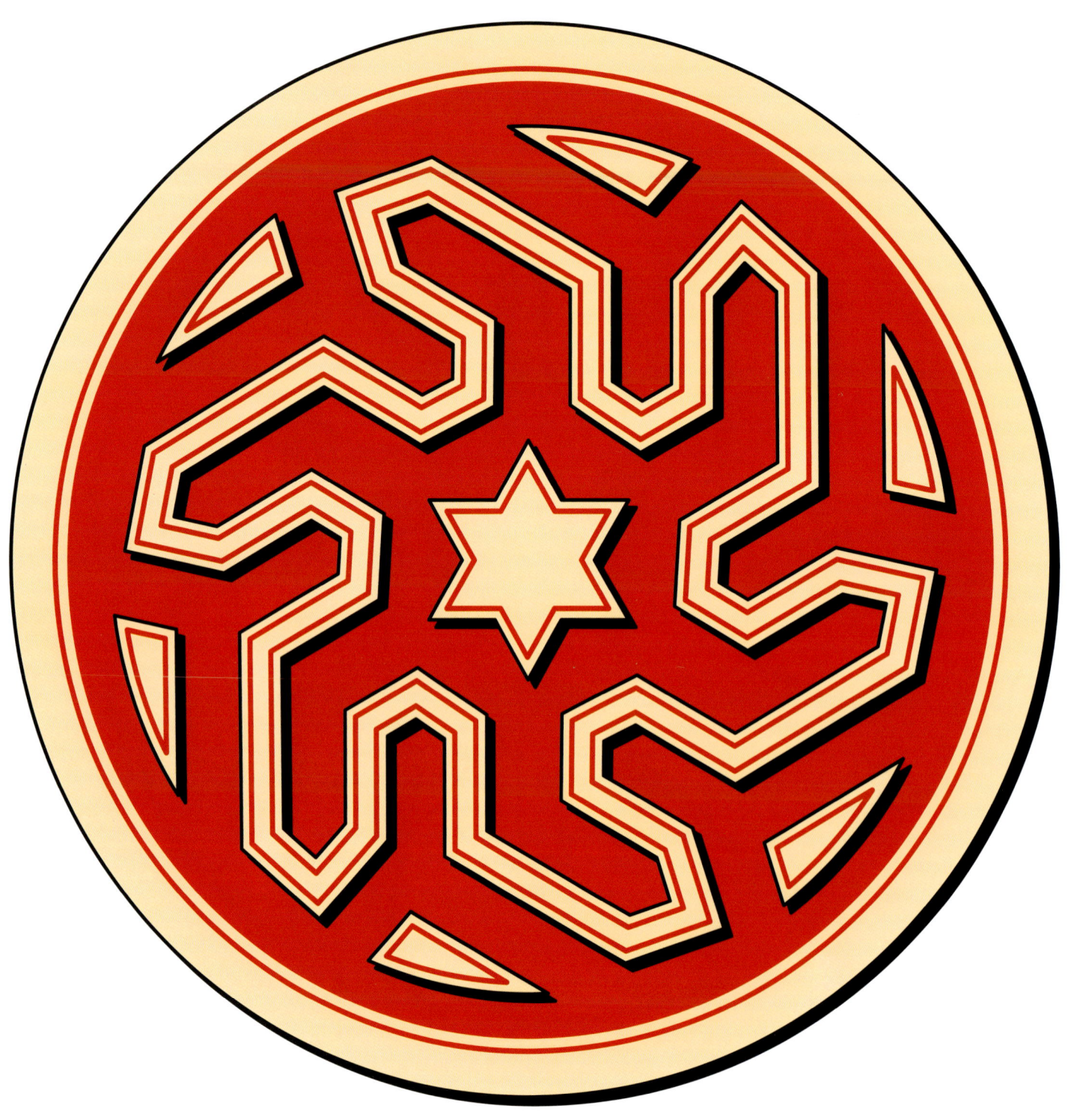

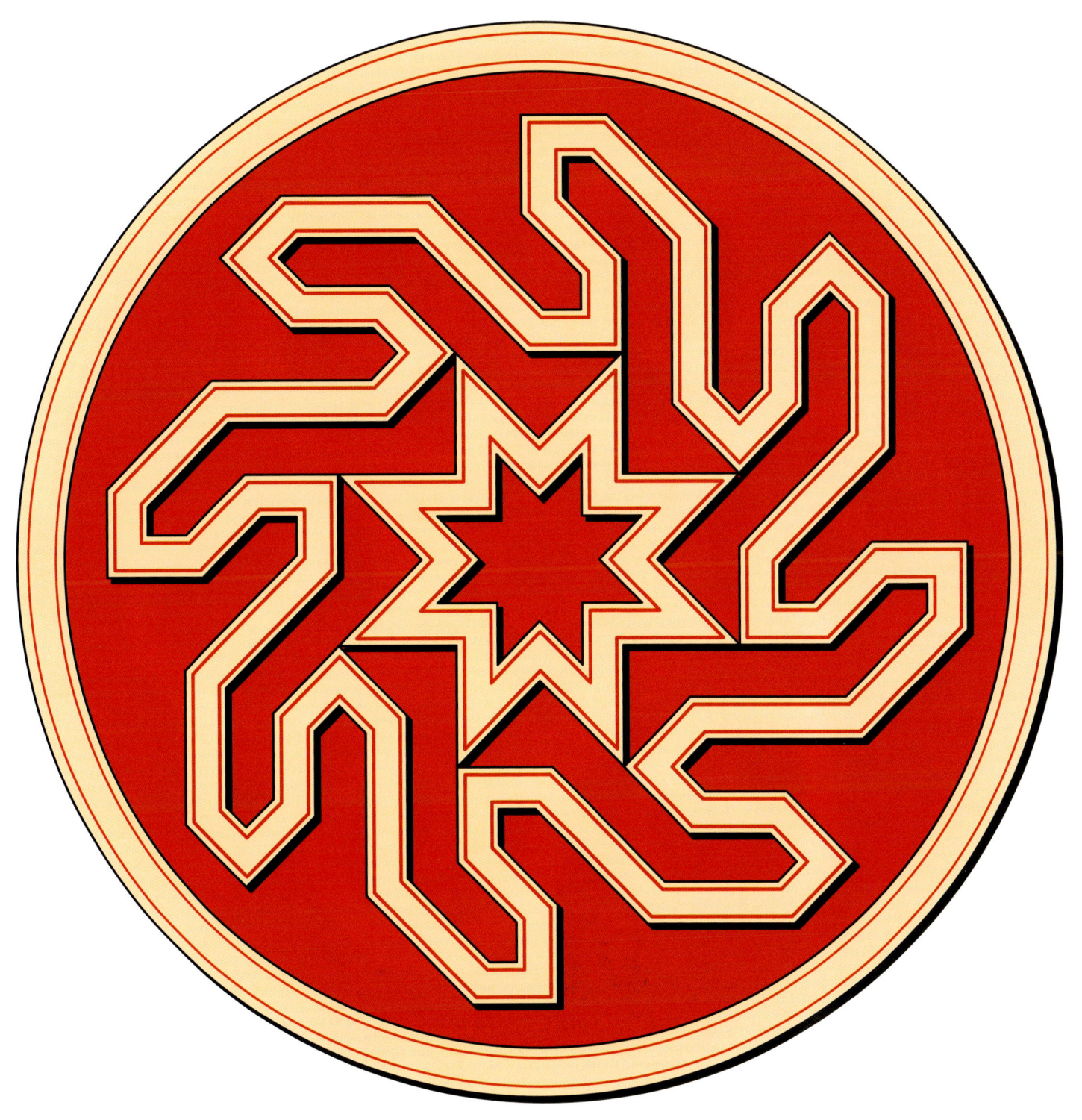

35

42

43

45

50

71

76

83

85

96

105

106

110